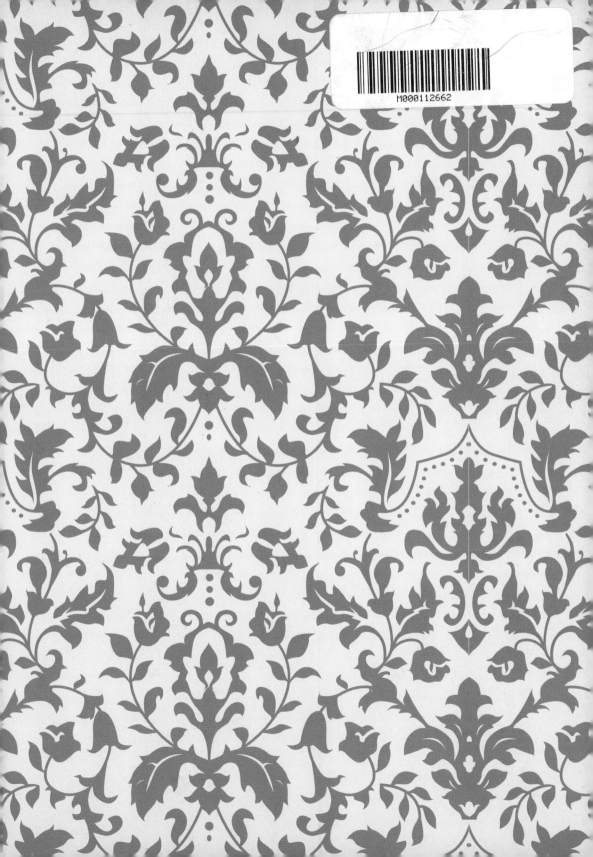

Madonna of the Toast
© by Buzz Poole

Design & Production: Christopher D Salyers
Editing: Jacob Albert

The author wishes to thank all of the people who provided their stories and photographs. He would also like to thank Jill Mullin, Daegan Palermo, George Zaninovich, Nate Anderson, Richard Rosenbloom, Jon Wolf and the whole Mark Batty Publisher crew, all of whom helped make this book possible through the luxuries of time and space. And Tina Wein, for a killer title!

This book is typeset in FF DIN, Didot and Ministry.

Library of Congress Control Number: 2006934567

Printed and bound at The National Press, Hashemite Kingdom of Jordan

10 9 8 7 6 5 4 3 2 1 First Edition

This edition © 2007
Mark Batty Publisher
36 W 37th Street, Penthouse
New York, NY 10018

www.markbattypublisher.com

ISBN-10: 0-9772827-7-5
ISBN-13: 978-09772827-7-7

MADONNA
of the toast

by
Buzz Poole

Mark Batty Publisher
New York City

Table of Contents

Introduction

Introduction

Pareidolia Self-Destroya?

Pareidolia (from the Greek *para-* amiss, faulty, wrong + *eidolon*, diminutive of *eidos* appearance): A psychological phenomenon elicited by random visual stimuli being mistakenly perceived as recognizable.

Daydreaming: one of the more casual and harmless pastimes us humans indulge. So different than the dreams that descend upon us as we sleep, for those we cannot control; we are simply along for the ride. Whether zoning out in class, work, talking to a loved one, or as you read, we all daydream. While daydreaming may be initiated by boredom, how it develops is something we control. Letting our minds chase psychic tangents, many of which not even we as the dreamers, as the ones who send our minds out on these mental jogs, is as natural as breathing. It just happens, set off by a noise, aroma or flash of light. It is not something that is taught. There is no lesson plan on how best to use your imagination; it is something our minds are hardwired to do (yes, some minds leap and bound more than others, but we all buy into the power of pretend to one extent or another).

I clearly remember the first time I knowingly went through the daydreamer's trap door. It was nursery school, and it was naptime. I never wanted to nap, so typically I would work hard to alter the realities of the situation. I groused at the teacher, prodded friends, moved around as if I would escape the physical confines of the room and the teacher's insistence

01

02

As humans, we recognize human forms everywhere, even in frosting.

that I sleep. And of course, these tactics never worked. I would either be reprimanded or made to endure my self-inflicted misery, fidgeting on the blue mats we were forced to stay on for the duration of the time.

But this one time, perhaps resigned to the fact that no amount of acting out would free me from the dreaded naptime, I dutifully sprawled out on my stomach. With both my hands balled up into tiny fists, I set my closed eyes on the tops of my hands. The effect was one of warp-speed time travel, as pyramids of green-gold light radiated with every blink of my eyes, allowing my mind to think it, and my body, were trundling through some wormhole of time and space, liberated from the mundane idea of sleep.

Of course, back then, I did not think of it in quite the same terms, but I did regularly return to the fisted phenomenon, because I saw things that I otherwise never saw: shapes and faces coursing by as I trav-eled deeper and deeper into these waking dreams of escape. And so now when I catch myself think-ing about an old girlfriend as I watch a tree branch bustle in the wind because it reminds me of a neck-lace she had, I am aware of two things: that my mind sees in those leaves the necklace and that the leaves are not the necklace, though it is what I see.

As humans, we have long struggled to discern between object and image, something Plato under-stood all too well. It seems to be part of our nature to favor the image over the object, no different than Plato's story about the people in the cave too busy watching their shadows flickering against the cave wall to notice the real world right behind their backs.

Today, the world is projected and replicated through an endless tumble of digital and filmic images that many people consider real, though they are no more real than those time travel images I fancied as a child (and admittedly still enjoy as an adult).

The purpose of this book is not to parse the meanings of "object" and "image." Rather, in the following pages, you will find images of images, many of them of recognizable forms and faces, from the religious to the celebrity to the absolutely absurd, though they are all believed in by at least one person, if not droves of people. This is the purpose of *Madonna of the Toast*, this human inclination to see that which we most want to see, although it is not intended to be there. What is even more interesting is that though you may have never recognized the face of the Virgin Mary in, let's say a grilled cheese sandwich, once one person has identified it, many, many others do too.

Such associative power is the significance of these photographs and their accompanying stories. It really doesn't matter whether or not you see the faces, because many, many people do. Not only do they see them, but they often believe in them, deeply, with the devotion of religion and sense of self.

The believers and nonbelievers alike recognize the valve of these finds. Whether on the level of sacrosanct devotion or pop culture kitsch, these forms become as relevant as the world's finest art because they compel people to react; the objects in this book, emblazoned with faces and symbols recognized the world over, have been appraised at stunningly high sums, been toured around the globe and have

Did you know?

From Talmudic and Chinese traditions to Plutarch and Elizabethan writers, the Man on the Moon has long been a part of human cultures. As John Lyly wrote in 1591, "There liveth none under the sunne, that knows what to make of the man in the moone."

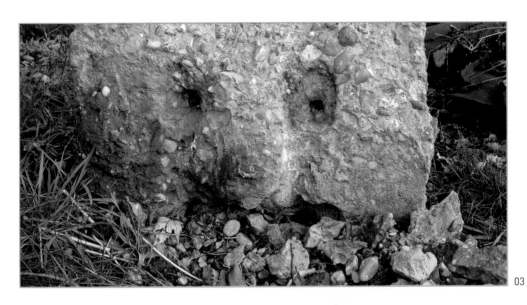

03

04

What do you see?

inspired people to travel, pray and steal. And in the name of what? That the hoagie you are about to gnaw a hunk off of or the slice of pizza just dropped on the counter in front of you looks like a young Rob Lowe, or that one piece of spider roll resembles James Bond — Roger Moore to be exact? And don't go looking for these examples because they are made up, right from the brain of your friendly writer. Do they sound silly? Of course they do, but they are not different from many of the examples in this book. Pope John Paul II on a pancake? Jar Jar Binks on a shed door?

And one way or another, these stories and images are shared. People want to share it with the world as a means of communication.

This is the world we live in. This is how we see it. What does it say about us humans today?

What do you see?

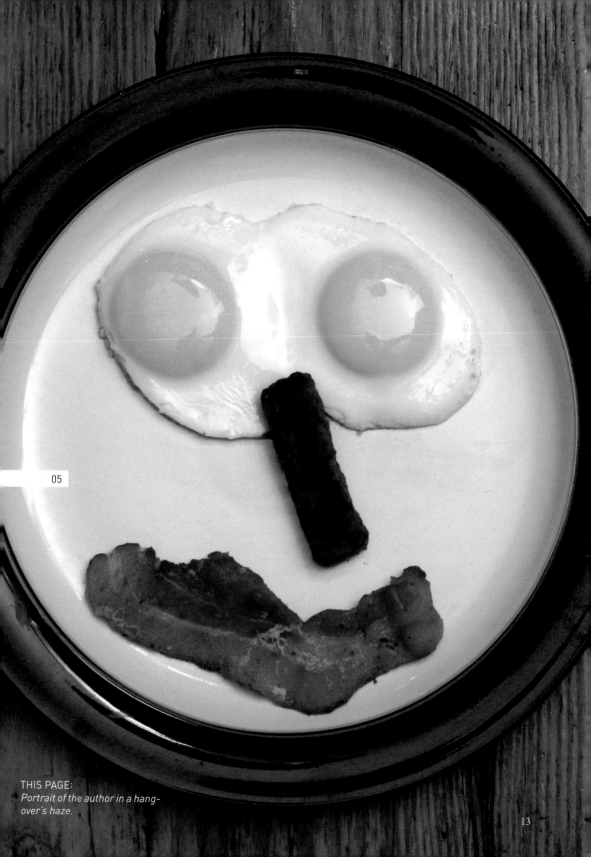

05

Secular Sightings

Myrtle's Chips

"Sometimes you can't even hardly believe it happened, you know, being on his show and the life, the Cinderella story that I have lived since then."
—**Myrtle Young**

"To Marge, I leave my potato chips that resemble celebrities."
—**A line from *The Simpsons* episode "Selma's Choice."**

Of all the examples of iconographic figures show-cased in this book, Myrtle Young's world famous collection of potato chips is surely the perfect point of entry. She has been a guest on countless talk shows the world over, and her 1987 appearance on the *Tonight Show* with Johnny Carson is a crispy bite of television history, one that the writers for the *Simpsons* deemed worthy of parodying. When Carson invited Young to talk about and show off her collection of potato chips she collected as an inspector at the Seyfert Potato Chip plant in Fort Wayne, Indiana, she of course obliged. Though her collection of chips that look like everything from smiley faces to Bob Hope, numbers over 300, Young typically traveled with 50 to 75 of the choicest chips. As she talked about the collection, Ed McMan, Carson's sidekick, distracted Young with a question, which the ever-courteous Young answered.

A crunch is heard and Young looks as if she is going to have a heart attack as she turns to see Carson chomping away on a chip. Of course, the gag had been planned, and Carson was eating a chip that looked like nothing other than a grease-ridged, salted, thin slice of potato.

Myrtle Young, still young at heart and not looking too much different than when she appeared on the Tonight Show, *which earned her a spot in* TV Guide's Funniest TV Moments of All Time.

06

Did you know?

Not only did Myrtle Young and her potato chip collection appear on countless American television shows, but she has also been a guest on shows in Canada, Europe, Japan and Thailand, and her story has been covered all over the world.

Fast-forward to 1993 when the *Simpsons* episode "Selma's Choice" originally aired. Like any episode, countless references to popular culture are peppered throughout, but one is particularly worth noting. After attending the funeral of Marge, Selma and Patty's great-aunt Gladys, the family watches a video will, in which Gladys bequeaths to Marge her collection of potato chips that look like celebrities.

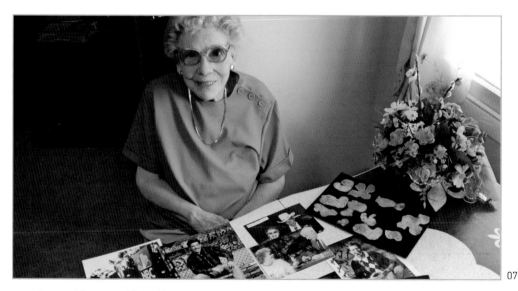

07

Young with some of her chips and mementos from Holly-wood and beyond.

As the news is delivered, Homer is seen downing chips, one that looks like Jay Leno (a bouffant hairdo and uppercut chin) and one that looks like the famous picture from Iwo Jima when the Marines raised the American flag on top of Mt. Suribachi.

And so it comes full circle: popular culture mirroring popular culture being spoofed by popular culture, all because of some potato chips that a woman from

Indiana started collecting for her granddaughter.
The power of the visual is boundless, as Young has
discovered since she first noticed the shapes.

Young applied for a job at Seyfert back in 1970,
after divorcing her husband and needing a job to
support her and her daughter. "I was an independent
woman, still am," the octogenarian happily states.
The day after she submitted her application, she
was hired. As with all new hires, Young was trained
in all aspects of potato chip manufacturing, but by
early 1987 she had been promoted to Potato Chip
Inspector. Her job was to make notes about rejected
chips, and then throw them out. Since the chips
would otherwise be wasted, Young saw no harm in
taking some that looked like Yogi Bear and Rodney
Dangerfield home to her granddaughter. News of the
growing collection made its way into the local media,
and Young's star began to rise.

Ever the consummate Indianan, David Letterman
read of Young and had her on his show (she was a
guest twice). From there, the offers poured in from
all over the world. Young became the global spokes-
person for Seyfert Chips, as well as the touchstone
for people to celebrate recognizable shapes in every-
day objects.

Of course, religious history from the world over has
always included such visual manifestations, from the
Shroud of Turin to the image of Our Lady of Gua-
dalupe that appeared on the *tilma* (cloak) of Juan
Diego in Mexico. People have always reacted to that
which appears before their eyes, using these forms
of visual communication as signposts by which to
steer their lives. The visual gives people something

Did you know?

In 1853, George Crum is
credited with creating the
potato chip, after a diner
at Moon's Lake House in
Saratoga Springs, New York,
complained that the French
fries were not crispy enough.
The advent of mechanical
potato peelers in the 1920s
converted potato chips from
a specialty food to the mass
produced, crispy snacks we
enjoy today.

From top to bottom, potato chip elephant, Mickey Mouse and Yogi Bear.

08

09

10

tangible, something that can be felt, held, sketched and photographed, in a way that an ideology cannot be contained.

In the context of contemporary life, however, where the rate at which information is transferred ever increases, even the visual manifestations of religious icons, no matter how devout and dedicated those who discovered them and those that flock to serve as witnesses, by virtue of the dissemination of news become parts of popular culture.

Just consider the case of Myrtle Young, a woman who readily admits that if not for her chips, she never would have been able to jet all over the world.

Young held her position as the global ambassador for Seyfert Chips until her retirement in 2000. Aware that her notoriety was a boon for his company, Mr. Seyfert commissioned a set of custom-made carrying cases for Young, so that her prized collection could be safely shuttled around the world. The cases are in fact plastic sweater boxes installed with three shelves padded with cotton batting and tissue paper.

Though, to this day, the collection resides in the third bedroom — appropriately named the "chip room" — amongst all the memorabilia collected from her travels wherever Young was booked, huge insurance policies were taken out on the collection, so as to indemnify the host party from being responsible for the destruction of the famed collection.

Which brings us around to the central issue of Myrtle Young's story, and all of the stories included in this book: Why are people so affected by these visual

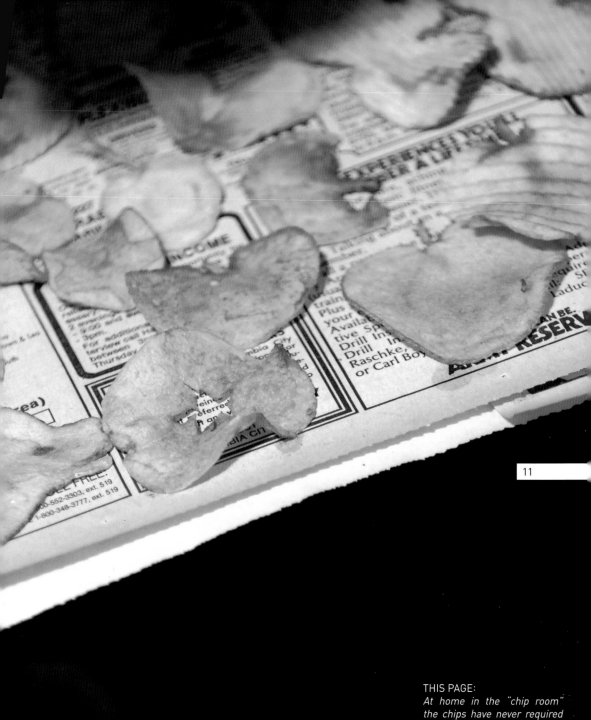

THIS PAGE:
At home in the "chip room"
the chips have never required
much for storage other than
some newspapers and shelves.

OPPOSITE:
The Bob Hope potato chip next
to a headshot of the man him-
self.

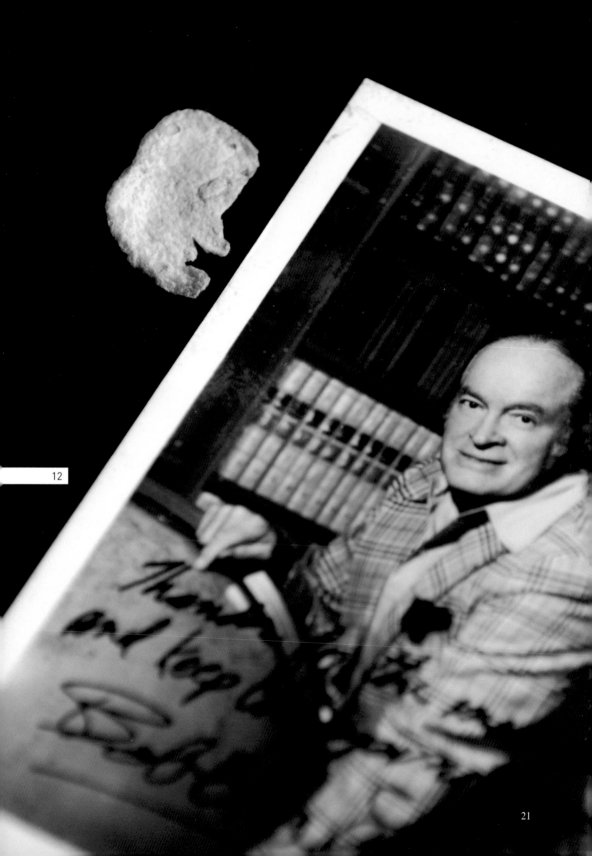

12

manifestations? Why do producers and writers spend thousands of dollars to get a woman and a couple of boxes worth of potato chips on television or onto the printed page? Why do people flock to see these events, for that is often what they become, vigils, reverent displays of dedication for something at once inexplicable, yet totally ordinary?

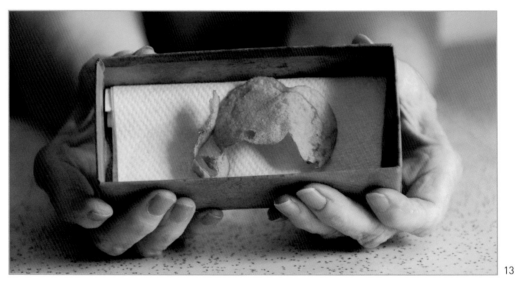

13

In the case of Young, her answer is simple: "Potato chips are something everyone can relate to and identify with." The reasons for the anomalies are matters of make up of individual potatoes and the varied machinations of the potato chip manufacturing process.

And ultimately, it is testament to the human spirit to see that which it cannot readily and physically grasp.

Who needs shellac and deep freezers when you've got paper towels?

From top to bottom, potato chip embryo and George Herbert Walker Bush.

14

15

Because Young's pinnacle of celebrity came pre-Internet, images of her chips are not readily available online, and those you can find are typically black-and-white reproductions from newspapers. Many people remember the *Tonight Show* bit, but not the chips. It only seems logical to ask what is to become of the chips. "They are such a big part of my life," Young says, "I can't part with them. Because of the chips, I've seen the best in the world, and the worst." So in the past, when Ripley's Believe It or Not, or the Potato Museum in Washington, DC, or a children's museum in Indianapolis offered to add the chips to their permanent collections, Young has declined, more than content to have them remain close to her in Fort Wayne as part of the family.

Bolshevik Suds

On the Internet, Phil Plait is the Bad Astronomer; his website is a haven for the skeptics and astronomers among us. On this terrestrial ground upon which we all tread, Phil Plait is Dr. Phil Plait, and he works in the physics and astronomy department at Sonoma State University in California.

In November of 2003, Plait found himself visited by an image that even his discerning eye could not deny: the face of Vladimir Ilyich Lenin. The leader of the bloody 1917 Russian Revolution carried out by the Bolsheviks appeared on Plait's shower curtain, on a day that had started out like any other.

Morning ablutions complete, Plait had reached out of the shower for a towel so he could dry off and enjoy the lingering heat, so as to stave off the chill of a Northern California November morning. He instantly recognized the face looking right at him as that of the infamous Russian.

As a highly trained professional, Plait is no stranger to the phenomenon of pareidolia. It is after all the reason for people seeing the Man in the Moon or the face of Jesus (as seen in a photograph taken by the Hubble Telescope of the Eagle Nebula). But this particular countenance – the high, bald forehead, furrowed eyebrows, eggplant nose and facial hair – even Plait concedes is the best example of pareidolia he has ever seen.

What beef did Lenin have with Plait? What cosmic circumstances aligned to transport Lenin to 21st-century California? What message did Plait decipher

Did you know?

Lenin's preserved body has been on public display in Moscow since his death in 1924. Prior to embalming the creator of the world's first Communist state, Lenin's brain was removed in order to study it and determine what made him a "genius." Fitting that his head showed up in this visual manifestation.

from the manifestation? Had Lenin returned to revel in the shortcomings of capitalism?

Like any good scientist, Plait deduced a reason for how the face appeared, but it had nothing to do with the paranormal or divine. When Plait grabbed the towel, his wet arm brushed against the curtain. The motion and moisture of his arm reacted with the curtain's material and formed the face. Luckily, a camera was nearby, because the face didn't last for long, though it certainly made an impression.

If you're shy, you probably don't want anyone seeing you in the shower, let alone V.I. Lenin.

16

17

Medusa Lesson

Photographed in Australia's Jenolan Caves, this rock formation has long been considered to bare the likeness of Medusa. Medusa ranks high on the list of all Greek mythological figures in terms of notoriety. Her likeness and name have been used throughout time by artists like Salvador Dali, to heavy metal bands. It is even the name of a roller coaster in New Jersey. What is it about this woman that turned all living creatures to stone that has translated across cultures and centuries so that she is the default icon of being scary and hideous and recognizable the world over?

The story is as simple as it is complex. As a young beauty, Medusa had sex with Poseidon in Athena's temple. Or, she was raped by Poseidon in Athena's temple. As punishment meted out by Athena for violating the temple's sanctity, Medusa's hair was turned to snakes and her gaze made lethal. From this perspective, Medusa is at once a wrongdoer and a victim. She either seduced Poseidon, or at least was complicit in their assignation, and guilty, or she was punished for something that she did not do, or want.

Like with all stories from mythology, however, there is much more to it than the narrative events. The real significance is how these stories are interpreted and represented throughout time. In the case of Medusa, she embodies the representation of the ambiguity of beauty and horror incarnate in a single form. But it is just that, a representation, not the object itself, but rather the image. Medusa has been propelled to the status of a double bind, in that she is at once the aggressor and the victim.

While some people in this book have reveled in their discoveries or turns of circumstance, others have not felt so lucky. Because so many of these icons are so culturally loaded, they can provoke verbal attacks, robberies and hordes of gawkers, all making for a less than ideal existence.

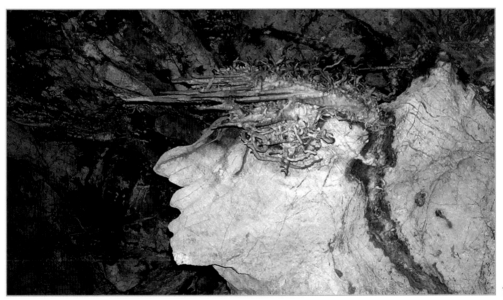

18

Located in Australia's Jenolan Caves, the Medusa Rock is an outcropping of limestone in what is considered to be one of the oldest open caves on the planet, dating back 340 million years.

Perseus eventually killed Medusa by looking at her reflection in a mirror, preventing himself from turning to stone. What better way to end such a tale, especially in the context of this book? No matter your perspective on these objects, they are visual manifestations of recognizable icons, many of which have never existed in this temporal world of ours. We as 21st-century citizens have never cast our eyes on these holy figures and cartoon characters. But we know them, recognize them because of endless

visual renderings of their forms. The same can be said for the celebrity shapes: stark profiles and noticeable physical traits fed to us night after night on televisions, or in newspapers, or on the silver screen.

Perseus used an image of Medusa to slay her, propelling her to mythical status. Her reflection saved him. Like the ambiguity so present throughout the myth of Medusa, her reflection resulted in her death and Perseus' life.

The objects collected here are objects of images that people sanctify, or are at least curious enough to trek across town to take a look. But in this world where reality and virtual reality blur, the real questions become: What are we looking at? What do these manifestations do for us? For they are certainly not actual representations of these icons. These are images of images, imaginations of hope and belief, the desire to see and touch peace of mind. Some may find these phenomena sacrilegious, blasphemous, stupid, dumb, or simply fake. But ultimately it is up to the individual to make those decisions and see what they see, regardless of what they are or are not looking at.

And perhaps that is the underlying lesson of it all, that belief and hope are everywhere, and I suppose that's better than them being nowhere.

Did you know?

The stop-motion photography of Ray Harryhausen, a pioneer of cinematic visual effects, makes the movie *Clash of the Titans* a memorable retelling of Greek mythology, although the film took many creative liberties. In the movie, after Perseus beheads Medusa, he throws her head into the sea. According to the original myth, however, he gives the head to Athena who puts it onto her shield.

Michelin Carrot

George Woodhall has always enjoyed eating the vegetables he grows in his garden. In September of 2002, however, the retired steelworker dug up a carrot that wouldn't be making it into his next salad. The reason? This carrot looked like the world famous Michelin Man. Conceived in 1898 by Andre Michelin's brother Edouard, the roly-poly character, actually named Bibendum, is one of the world's most recognized corporate symbols. So much so that anyone who gazed upon this disfigured carrot immediately saw the Michelin Man. "Soon as I yanked it out, I thought it the absolute spit of the Michelin Man," Woodhall recalls, his voice pleasant with a rural English accent.

19

Action figure + vegetable = very happy old man.

Word of Woodhall's discovery quickly spread through his neighborhood of Worsbrough Bridge, Barnsley. Curious neighbors soon gave way to the local paper, which attracted hundreds of people from all over the UK. On a daily basis, people came to gawk at the 8-inch carrot, as if it were a message. And in the pantheon of advertising, it is a revered figure that has endured the duration of the dicey 20th century, and shows no sign of flagging in popularity. Testament to that, the Michelin company even got in on the action. "A big fella came in uniform," Woodhall says, "came with all manner of sweets and balloons for all the children. Looked just like him."

The story of the carrot became national news, with requests coming in from telvision and radio outlets eager to interview Woodhall about his carrot. Woodhall refused all of the requests, on the grounds that he just isn't "the type of person to go on TV and radio." He adds, "I never liked London anyhow, too bustling." Even though Woodhall never made it to London with the carrot, it was the vegetable's final

resting place. After much insistence, a Channel 4 television program convinced Woodhall to send the carrot to London where it appeared alongside Tom Hanks and *EastEnder* Ross Kemp. "There it was, right at the tail end of the program," Woodhall says, "Was the last time I ever saw it."

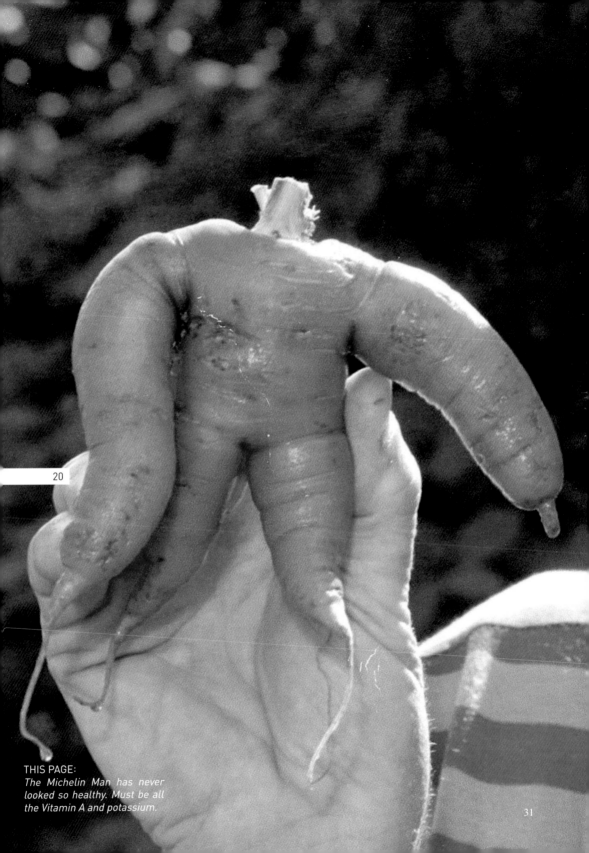

20

THIS PAGE:
*The Michelin Man has never
looked so healthy. Must be all
the Vitamin A and potassium.*

J.F.K. Rock

It's fair to say that when John F. Kennedy was assassinated, many Americans lost hope, hope instilled during the civil rights movement, hope that real change can be created from the ground up. Penned the same day of the assassination, Hunter S. Thompson wrote to his friend, fellow writer William J. Kennedy, that, "The savage nuts have shattered the great myth of American decency." In the same letter, Thompson coined the oft-used phrase, "fear and loathing," to describe his feelings about the shooting.

The name Kennedy continues to conjure thoughts of American royalty: beautiful people, lovely homes, yachts, mistresses, privileged children. And for those old enough, the name transports people back to one of the most infamous days in American history: November 22, 1963.

Of course, it is not fair to say that hope is dead in America, just look at the pages of this book. They are filled with stories about people's hope, their faith in the inexplicable. It is with hope that certain of these images are seen and flocked to by believers.

Certainly that's the case with this striking profile of JFK, a 50-foot-high basalt rock face in the Iao Valley's Black Gorge on Maui in Hawaii. Chiseled out by weathering and plate tectonics, the lines on this rock echo those of the 35th President of the United States: the solid shelf of healthy hair, the beak-like nose and the little spit of a chin. Neither the visitor's bureau nor locals familiar with the region can pinpoint exactly when the rock earned its name, but they all seem to think it happened in the 1960s, not too long after the assassination. You can imagine a

Did you know?

President Kennedy visited Hawaii in June of 1963, just months before that fateful day in Dallas. He rode from the Pearl Harbor Memorial in an open convertible to Waikiki where he delivered a speech to a meeting of American mayors. During the motorcade, Kennedy shook hands and accepted leis from people who lined the streets to catch a glimpse of the thirty-fifth President.

hiker out for a meditative stroll one morning in the 60s, dwelling on the tumultuous state of the world, rounding a bend and being struck by this profile, gilded by the morning sun: a natural monument to political and cultural hope for a better world.

Unlike certain examples in this book, this one has changed over time. It has sunk into the hillside, but still maintains its famous face. Of course, if Kennedy were still alive, he would be old and wrinkled, an aged version of the youthful vigor that the nation swooned over decades ago. In this sense the changing of the rock is fitting since no matter how mythical JFK may seem, he was only human.

Plate tectonics have diminished the starkness of Kennedy's profile, but it still looks like number 35, the most dashing President.

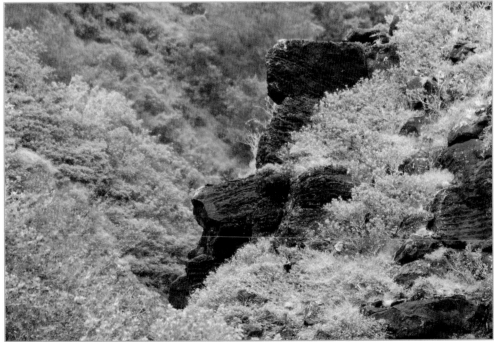

21

Mickey Go Moo!

How much can one guy riff on recognizable shapes and the ramifications of their existence? How much can be said about a Holstein cow with a spot that looks like Mickey Mouse, replete with the big ears? Well, the cow's name is Minnie Moo; she was born in Edgerton, MN. Walt Disney World Resort in Orlando, Florida, acquired the cow in 1990. She lived at Grandma Duck's Farm, Magic Kingdom Park and the petting farm at Disney's Fort Wilderness Resort and Campground before she moved onto the great big pasture in the sky at the ripe age of 15. (On average, Holstein cows live to the age of 12.)

That's it, right? Of course Disney would be keen to show off a cow with a patch of hair naturally shaped and colored like the company's most recognizable character so that kids could pet it and watch it chew cud. How cute.

But there's more to it than a fuzzy photo op for families to hem and haw over in their post-vacation revelry. The details of the transaction between the farmer in Minnesota and the corporate behemoth are sketchy, at best. Spend enough time perusing Disney-related message boards and two different stories take shape. One version of how the cow moved from its northern climes to Florida is that the farmer donated the animal because he thought it appropriate. The other version of the story is that Disney caught wind of the cow and its unique mark and seized it in the name of copyright protection.

Disney's beloved mouse made his debut in 1928, with many of his other cohorts like Pluto, Goofy and Donald Duck coming along not too long thereafter.

Did you know?

Holsteins are the most common breed of dairy cattle in the world. They make up nearly 90% of the 10 million cows that live in the United States. A mature Holstein weighs in at nearly 1,500 pounds.

According to preexisting copyright law, Mickey was due to enter the public domain in 2003, and his friends would follow. The Walt Disney Company, none too happy about this prospect, commenced an aggressive lobbying campaign to change the terms of copyright law in order to favor them and their empire of amusement. They enlisted the help of then-junior congressman Sonny Bono, among others. The act, named the Sonny Bono Copyright Term Extension Act, was passed and signed by President Clinton, providing Disney, and others, a twenty-year extension on their respective copyrights.

Those opposed to the act called it unconstitutional, claiming it was not in-line with Congresses' Constitutionally mandated power, as found in Article One, Section Eight, Clause 8, "To promote the progress of science and useful arts, by securing for limited times to authors and inventors the exclusive right to their respective writings and discoveries." Those who view the Sonny Bono Act as troublesome, argue that the prickly nature of this debate stems from the idea of "limited times." What it comes down to is that many people believe that corporations should not have the ability to change the Constitution for the sake of the bottom line. Opponents, however, have not been able to win their case; in 2003, the Supreme Court upheld the Constitutionality of the Sonny Bono Act.

And so, it really doesn't seem that farfetched that Disney, a company willing to instigate changes to America's law of the land, would keep a cow in a corral to protect their copyright on a cartoon mouse, whether it is traced or in the form of hair. I guess the old Italian proverb, "All is not butter that comes from the cow," is true.

Minnie Moo's marking are unmistakable. Wonder how the milk tasted?

22

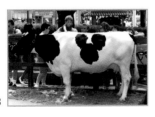

23

Mad Monk Cat

Cats. You either love them or hate them. The wonder of our feline friends is the very fact that we do not understand them. Unlike dogs, a far more overt domestic animal, what with all the tail wagging, drooling, barking and pawing, cats tend to be more aloof, and consequently misunderstood. Cats are self-reliant, though they are also very clearly conniving and calculating, knowing how best to utilize their human companions for food and shelter.

From this perspective, what better an animal than a cat for the infamously controversial Grigori Rasputin to show up on? Rasputin's legacy as one of the 20th century's more maligned figures is well established, thanks to his hedonistic ways and his influence over Tsar Nicholas and his wife Alexandria, Russia's final imperial rulers. Rasputin got into the good graces of the royal family because he was credited with helping Nicholas and Alexandria's son Alexei with his hemophilia.

The extent to which Rasputin actually treated the medical condition is matter of debate, but what is certain is that the appreciative father and mother welcomed the "Mad Monk" into the palace, and in turn into the homes of Saint Petersburg's elite. While many reviled Rasputin for his vices of sex and alcohol, just as many, especially women, were lured to him by virtue of his charisma alone.

Already a much-discussed personality in Russia, Rasputin secured his reputation as a loose cannon during World War I. He insisted that Tsar Nicholas should take on his role as the leader of Russia and take command of the military. Nicholas listened to the bad advice, and went off to the front. As the war

raged on, Rasputin appointed his inner circle to government positions, using his leverage with Alexandria to secure the appointments. To the Bolsheviks, this network of nepotism embodied all that was wrong with the imperial system and fomented the revolution, as well as Rasputin's mysterious assassination.

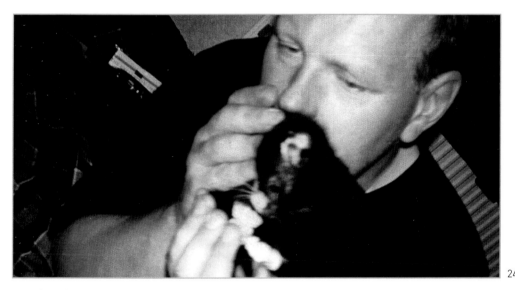

24

Even the less than ideal image resolution makes clear the forehead, eyes and beard of Rasputin.

Yet, here is his face on the inside of this cat's ear. The cat's name is Honey Bear and it belongs to Tony Unstead (at the time of writing, it was impossible to contact Unstead). The high white forehead and the long tapered beard make Rasputin's face recognizable; the eyes stare a hypnotic gaze.

As easily as many see Jesus or the Virgin Mary in various places, Unstead saw Rasputin in his cat. I'm willing to bet that Honey Bear is not as sweet as the name suggests.

Elvis Has Left...

Jenna Cage had purchased two laptop computers from Office Depot, not too long after Christmas 2005. Her purchase included a mail-in rebate, which she had returned to the company immediately after getting the laptops. In February of 2006, she was riffling through old receipts to follow up on the offer because the rebate check had yet to arrive. She found the receipt, dated January 12, 2006, but something on the paper jumped out at her: the face of Elvis Presley.

Cage, a person who does not consider herself a fan of the King, recognized the face instantly. It seems to be in the stark hairline that runs down the side of the figure's face to form Elvis's patented sideburns. It's hard not to see the hip-weltering rock and roll pioneer, and when you really look at the receipt, it is hard not to see two faces: young Elvis and old Elvis. Again, the hair makes the difference. The image on top possesses that oil-slick fullness that America went ga-ga for back in the 1950s. The second image appears more bloated, and the ledge of hair has receded back to an over-worked comb over.

Even more intriguing is the fact that the Office Depot slogan, "Taking Care of Business," is the same name of Elvis's longtime band: James Burton on guitar, Glen D. Hardin on piano, Jerry Scheff on bass and Ron Tutt on drums. This legendary group of session players recorded and toured with the likes of the Doors, Johnny Cash, Jerry Garcia, Bob Dylan and Elvis Costello, but they cut their teeth in the music industry with Elvis. More than a band name, "Taking Care of Business" became a motto for Elvis and he even had the custom-made jewelry to prove it.

Did you know?

Other collectible Elvis receipts available for purchase originated from an auction of Lisa Marie Presley's memorabilia. One receipt from this collection documents how Elvis spent $135 per night to rent Libertyland Amusement Park in Memphis, Tennessee; another shows that the party ate 78 Pronto Pups (25¢ each), 22 ice cream sandwiches (15¢) and drank 87 Cokes (15¢), brining the grand total to $35.85. Libertyland closed its doors on October 29, 2005.

It only makes sense that of all these icons in the book Elvis would be counted among them. He is a legendary figure, famous the world over for instigating a musical movement that challenged societal boundaries and spread all over the world. He led a very public life; the highs and lows have been documented ad nauseum. People travel to Graceland as if it were a religious shrine. For years, people have claimed to spot him in gas stations and tiny out-of-the-way towns. He is a one-name icon that evokes America, for better or worse.

For all the speculation, rumor-mongering and genuine admiration that surrounds Elvis Presley to this day, unlike many of these objects, when this receipt was auctioned off on eBay it did not attract media hysteria. The anonymous winner of the receipt still has it. Perhaps it is Elvis himself . . .

Notice the two Elvis faces on the receipt, one young, the other old. Notice too that the face resembles a young Morrissey.

25

26

"Meesa Free?"

When you endeavor a project such as this one, unearthing what are often obscure examples of an accepted yet marginal phenomenon, the leads come fast and furious, though many of them don't pan out. Through a family member, I was told about this shed door in Maine on which the owners had spotted the *Star Wars* character Jar Jar Binks, who incited more vitriol from fans than any other of George Lucas's creations. At first I didn't believe it. I mean, Jesus, the Virgin Mary, Bob Hope, Mickey Mouse, these figures have made their impact on the world. They've influenced us, taught us how to see things differently and made us laugh. But Jar Jar Binks?

Though I've never been a hard-core *Star Wars* fan, I went and saw the prequel on the big screen when it came out in 1999. I didn't much like the floppy-eared jester. He struck me as little more than a mastur-batory display of technical prowess that lacked any relevance to the overall plot. A friend of mine posited that Jar Jar was meant to pander to kids and the marketing of toys (similar to Ewoks). It was clear that Jar Jar Binks was no Chewbacca, or CP30 (from the standpoint of many people's resistance to technology, it is worth noting that upon the release of *Star Wars* in 1977, people hated the robots as characters). I griped about Jar Jar for a few minutes with my friends after the screening and then let it go. Over the next few years, I saw the other *Star Wars* prequels and noticed how Jar Jar had clearly been phased out as the comic relief sidekick.

As I studied these photographs of the Jar Jar Binks face on this wooden door, I wondered, what is it about his presence in the vast spectrum of popular

culture that has resulted in him making an appearance at a cabin on a lake in central Maine. Turns out that Jar Jar Binks cleaves right to the heart of America's central cultural dilemma: race.

Many people interpreted Jar Jar Binks as a racist character, harkening back to Blackface Minstrelsy, or the shuffling, servile and simple-minded characters of Stepin Fetchit. Certainly, the actions and demeanor of Jar Jar Binks resemble those of an abused puppy, constantly seeking affirmation, though always prepared to flee. The aspect of Jar Jar Binks that really brought about the accusations of racism though was his Caribbean accent. More than an accent, however, phrases like "weesa goin' home," and "wasa meesa saying," sound exactly like the stereotypical speech of American 19th-century slaves and servants. Because of the general dislike of the character, compounded with these linguistic traits, it's no surprise that Lucas and company phased Jar Jar Binks out of the next two movies.

Jar Jar Binks's face really takes shape close up, where the eyes and nose are easily recognized.

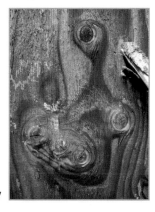

27

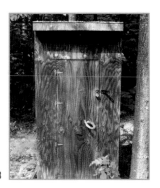

28

But still, how does a franchise synonymous with America, a character from the films and the issue of racism, come together in these knots in the wood? In his book about Minstrelsy and American popular music, *Where Dead Voices Gather*, Nick Tosches surmises America's intimate relationship with popular culture: "America alone of nations envisioned herself in terms of a dream. Nothing in this country is real, everyone an actor ... Popular culture is the product of who we are only in that it is the product of lies, pretenses, and falsehoods that define us, and beneath which hide and often, ultimately, lose the little truth from which we flee."

Strong words to be sure, but in light of this example, hauntingly relevant. In retrospect, it is hard to imagine studio PR people and lawyers letting a character like Jar Jar Binks out of the can for all of the reasons mentioned above. He did make it onto the big screen, however. This is not to suggest that there were overt racist intentions in the creation of Jar Jar Binks, but it is meant to suggest that Tosches has nailed why popular culture is so important. Without it, we have no cultural fabric to wrap around ourselves, though with it, we shield ourselves from uncomfortable truths that need to be examined.

In the case of this Jar Jar Binks on the shed door, we literally see the arc of his nostrils atop the beaked snout, as well as his eyes, popping out from his head. Figuratively, we see how embedded race is in the American psyche, so much so that it reared its head in what should have otherwise been a totally innocuous, and pointless, feat of technology. But it is more than that; look here and see more than movies, see the whole of American history, younger than the wood this door is made of, but older than you the reader.

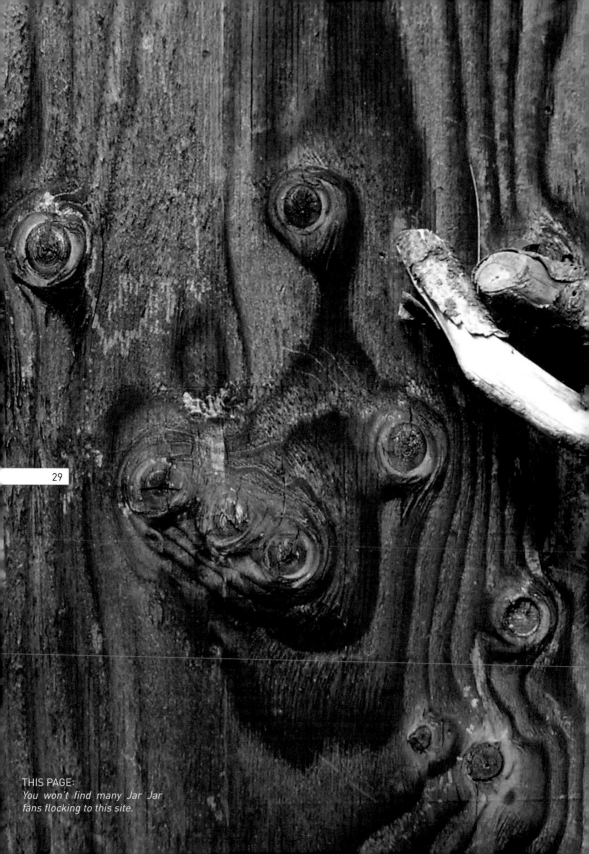

29

Forms of Faith

Jesus Mandolin

Annabel Hine went to a guitar show looking for the perfect mandolin. Her spending limit was $500, and after much looking and strumming, she found a Flat-iron Festival "A" style. "It sounded way better than anything else in my price range," Hine recalls, "so the following week I drove to the store in Rochester to buy it." She traveled to Bernunzio Vintage Instruments (now called Bernunzio Uptown Music), which after 20 years of operation in Rochester, New York, has established a national reputation for stocking unique, vintage instruments. The mandolin was a factory "second," meaning it contained some slight flaw that affected nothing other than the price. Hine had no idea just how special the mandolin she purchased from the Bernunzio's was.

Sure enough, Hine made the mandolin sing and twang. As with any new purchase of some emotional and monetary value, Hine spent extended periods of time with the mandolin, making sure that every time it went back into the case after a session of plucking, it was in as fine a condition as when she had pulled it out.

Shortly after she brought the piece home with her, putting it away for the night, she noticed what clearly struck her as a human face in the wood grain on the instrument's back. It was more than just a face. Hine saw Jesus Christ.

"I've always been the kind of person who thinks about 'meaning' and 'signs' but I'm not Christian," Hine says. Nonetheless, when she saw the face, she

You decide: Jesus Christ, Mr. Charles Manson or Jerry Garcia?

30

Did you know?

Borne from the sounds of Bill Monroe's Blue Grass Boys, blue grass is the American extension of folk music traditions brought to the United States from England, Scotland and Ireland. The music's framework relies on a melody being passed around and improvised by the players.

could think of no one else aside from the Son of God. She showed it to friends, who also saw the face, though some of them thought it looked more like Charles Manson, or Jerry Garcia.

It's hard to deny that the pattern in the wood has a human shape to it. The dark lines on either side of the face resemble hair, which is matched in the

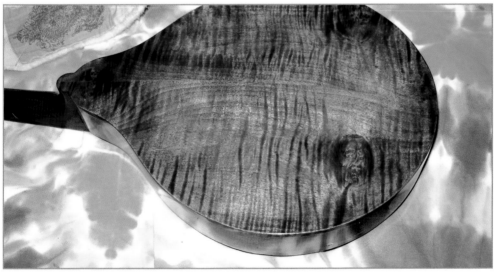

31

Unless you were looking for a face in the wood, it's easy to understand why it would go unnoticed for such a long time.

blotching under the nose and on the chin, moustache and goatee respectively. The eyes burn with intensity, but whether it is the intensity of divine peace or fiery rage is debatable. A student of Christian art would rightfully argue that the angular face defined by the gout cheekbones match the typical qualities characteristic of Jesus as portrayed in medieval paintings. For Hine, the quality that makes this an image of Christ and not Charles Manson is the crown of thorns

atop the head. Or is it a halo? It is clear that a band of light circles the figure's pate.

Hine took the mandolin back to Bernunzio's, not to gloat, but to share with them her discovery. John Bernunzio admitted that he had never noticed the face, something, according to Hine, he clearly regretted upon seeing it. With the value of such items appraised by the whims of eBay bidders, doubtless what he saw was not a former inventory item, but a lost opportunity at profit and notoriety.

Hine's day jobs include running a day care center and giving violin lessons. When the mandolin is not used for Hine's musical project, Annabel's Blue Grass Boys, it lives in its case, on top of her piano, "where it can't enlighten anybody."

Jesus Fryer

An anonymous Australian cooked this image of Jesus up for supper one night. It seems that the face formed after a lemon mustard cream sauce was whipped up. After the cook emptied the pan, it was placed back on the still-hot burner, causing the residual sauce to burn into this recognizable countenance. Anyone that has scrubbed a pan knows how resilient these crusty burns can be, as resilient as the faith that inspires people to find these faces in everyday objects.

Here, the large eyes and the closed mouth define the calmly concentrated face, seemingly channeling the divine spirit of His Father. Considering the image in the context of a meal, it is hard not to think of the Biblical story "Jesus Feeds the Five Thousand." Five loaves of bread and two fish, combined with a look up into the sky and a blessing, fed five thousand hungry people. Judging by the size of the pan, this meal didn't make it into that many mouths, though it is doubtless a meal that turned out to be just as memorable.

GoldenPalace.com paid $76 for this pan encrusted with the face of Jesus. It probably cost more to ship it from Australia.

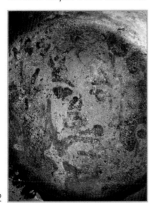

32

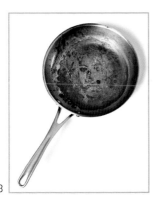

33

Jesus Pierogi

I called the Lee house in Toledo, Ohio, one evening during the week. Thomas Lee answered, but I wanted to speak with his wife, Donna. He asked what I wanted and I told him. Next thing I heard was his unsurprised, shouting voice: "Someone on the phone wants to talk to you about your pierogi."

Donna quickly picked up, though at first the apprehension in her voice was clear. I told her what I was working on, that I knew the general details of how she pan-fried pierogis for Easter supper in 2005 and discovered the face of Jesus burned into the side of one of the dumplings. She politely *hmm*'ed and reticently answered my questions.

There were eight people at the Lee house for dinner that night. Donna usually made her pierogis from scratch, but on this night she cooked frozen Mrs. T's out of the bag. As she stood over the pan, attending to the browning pillows of potato and cheese, she began to flip them so they would cook evenly. She noticed the face immediately, staring right back at her in the sizzling pan. She showed her guests the discovery. Everyone agreed it looked like Jesus, and that it was "weird" that the face appeared on the day dedicated to celebrating His resurrection. I asked Donna if she took it as a sign. She said, "I'm Catholic, but I'm not that far off the wagon, yet."

The pierogi was returned to the freezer, where it remained for a few months, as a secret shared only by close family and friends.

"Where are you calling from?" Donna asked me.

This little Easter surprise was auctioned off for just $1,775. Goldenpalace.com was the high bidder.

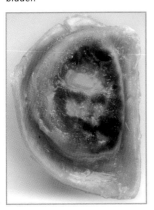

34

When she heard New York City she let out a whoop and started singing Sinatra, a punctuated burlesque delivery: "If I can make it there, I can make it any-where, it's up to you New York, New York!" The song seemed to unlock an emotional gate, because for the rest of the time we spoke, Donna eagerly answered my questions, often meandering into tangents.

She decided to make her Jesus pierogi public because a friend told her that some money could be made. Donna wasn't out for profiteering though. Her mother had recently passed away and she wanted to make a donation to a hospice in her mother's name. Placed on eBay in August of 2005, the auction received 44,000 hits and generated an avalanche of media requests. Reporters called from all over the world. Local television and radio wanted to do spots with the Lee's (Thomas did a few). Donna couldn't be bothered to return calls, answer messages or speak publicly, because for all of the positive attention the pierogi received, countless mean-spirited emails and phone calls were left, threatening and disparaging her for exploiting Jesus Christ.

A representative from Mrs. T's called. Donna said that the bag she pulled the pierogi from contained 13 dumplings; the person from the company said that was impossible, the bags were only supposed to con-tain 12. "I'm telling you," Donna said. "It was weird. But I like baker's dozens more than regular dozens."

The pierogi sold for $1,775, which Donna donated. "It worked out, but it obstructed my life. You think you're doing a good thing, but people don't want that. And I'll tell you what," Donna says, "if I ever find anything again, I'm not telling anyone!"

The Satan Turtle

For two years, Bryan Dora and his wife Marsha ran *A-Dora-ble Pet Shop*, at the time the only pet store in Frankfort, Indiana. The two started the shop as a result of their love of animals. At their home, they keep several dogs, saltwater tanks and a stocked koi pond in the backyard. Marsha would run the store during the day while Bryan worked his day job as an engineer, after which he relieved her and closed the shop.

One day, though, a fire, the cause of which has remained undetermined to this day, razed the store. Both the Doras escaped harm, but the same cannot be said for the animals, with the exception of one: a red-eared slider turtle. After surviving the tragedy, the turtle was appropriately dubbed "Lucky" by the Doras, who took the turtle home.

About three months after the fire, Bryan noticed a new pattern on the shell: the face of Satan. "The face jumped out at me like out of a screen," says Dora. While of all the images compiled in this book, this one may require the most squinting, the lines of a face, and more importantly the lines of a goatee and pointy horns are visible against Lucky's earth-toned shell. To be sure, the Satan that both the Dora's saw, is the one cut straight from the fabric of old *Looney Tunes*: a stark platform of jaw and chin, framed by prop-like facial hair and, of course, devil horns.

As with so many of these visual manifestations of recognizable icons, Lucky's shell found itself in the middle of a media blitz. "It got to the point that we would go into town and come back to 40 messages."

You really have to work the eyes to see this one, but that is an image of Satan staring right back at you off Lucky's shell.

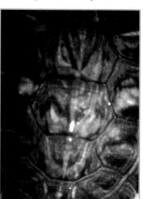
35

36

Calls came in from as far as England and the story was featured in *Reptile Magazine*. The media attention didn't bother the Doras; it was the hateful calls from priests wanting to do exorcisms that led Bryan to stop responding to the requests for interviews.

Bryan Dora is Christian. He doesn't believe that Lucky was somehow turned into a demonic vessel of evil. He posits that the face evidences the hand (or is it hoof?) Satan had in the fire, and that the markings on Lucky's back are to remind the world at large of Satan's reach and how religion can spare you suffering. Those less inclined to credit Satan for the appearance of the face on the shell attribute the markings to the extreme heat from the fire. Either way, the face was still on the shell the last time the Doras saw Lucky.

Done with the press, ready to move on with their lives, the Doras decided to let Lucky live free, so they put him in the koi pond behind their house. In the spring of 2006, they emptied the pond to prepare it for summer. Lucky was nowhere to be found. Dora figures that the turtle passed on or just buried himself down deep into the mud. Both possibilities leave the couple feeling that they did the right thing with the turtle.

Bryan and Marsha Dora never reopened their pet store.

The Nun Bun

Bongo Java in Nashville, Tennessee, enjoyed a great deal of media attention thanks to a cinnamon roll that resembled Mother Teresa. Ryan Finney discovered the saintly countenance on October 15, 1996, after showing up at work. Typically, when Finney opened the store in the morning, he would arrive around 6:30 a.m. to receive deliveries from the local bakers that supplied the café. The woman who made the rolls brought them to the café in their dough forms to be baked in the ovens at Bongo Java. She often had leftover dough, too little to be made into a saleable roll, but just enough for Finney's breakfast.

On this fateful day, however, the baker's batch did not include extra dough, and Finney was hungry. This wasn't the first time something like this happened, and usually what Finney would do is find the most misshapen cinnamon roll and claim it as his own. Little could he have known that the sweet breakfast treat he chose on this morning would become a choice that he would have to live with for the rest of his life. "One website called me a heathen," Finney recalls. "I was just trying to have breakfast."

Why would anyone want to call someone a heathen for just trying to eat a meal? Probably because this particular meal resembled Mother Teresa. What would soon become known the world over as the Nun Bun was almost eaten by Finney before he happened to notice the face of the modern-day saint staring right back at him.

Finney attributes his ability to see the face not to any deep religious affinity, but rather to his back-

Did you know?

In October 2003, Pope John Paul II beatified Mother Teresa, bringing her one step closer to being declared a saint. While Mother Teresa has been credited with the miracle of curing a cancerous tumor, some have disputed it because the woman's husband initially cited modern medicine as the real reason behind his wife's recovery.

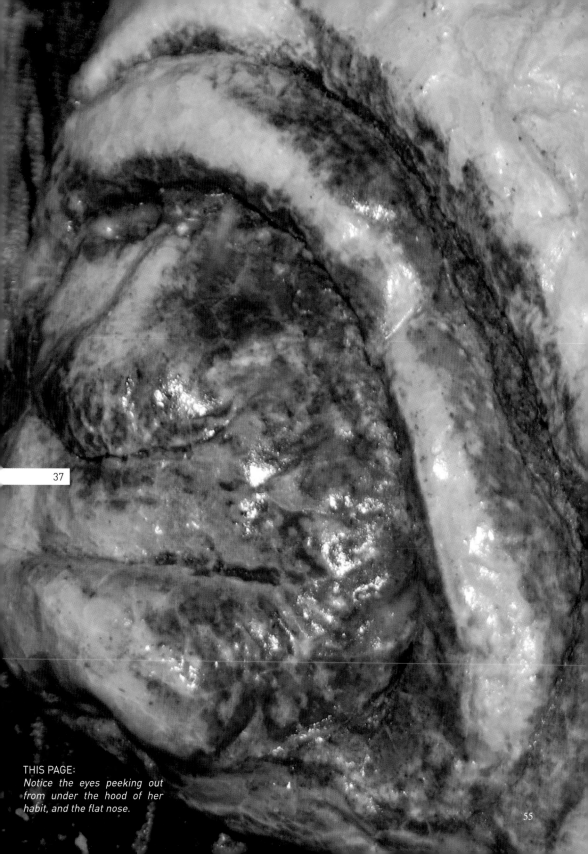

37

THIS PAGE:
Notice the eyes peeking out from under the hood of her habit, and the flat nose.

ground as a painter and cartoonist. "If you have an eye for form," he says, "it's not so hard to see faces in all sorts of places." It just so happens that in this instance, many people saw the same face.

At Bongo Java that morning, Finney's coworkers arrived and he showed them the bun; they all saw Mother Teresa, as did the morning's first customers. Soon after, Bongo Java's owner, Bob Bernstein, became aware of the bun. "I saw Jimmy Durante more than Mother Teresa," he confesses. Whether it was Jimmy Durante or Mother Teresa, everyone agreed that this confection did in fact look very much like a human face. Hooded in the swirl of the bun, eyes set above a lumped nose, the face's mouth is serious, as if *hmm*ing through tight lips in response to the confessions or pleas of one in trouble.

As more and more people weighed in on the Nun Bun debate, it became clear that an excellent publicity opportunity existed for Bongo Java. Due to circumstances beyond the scope of the Nun Bun, Finney left Bongo Java, and the state of Tennessee, not too long after he made the discovery, and before the avalanche of media attention.

When the media caught hold of the story, it grew from a local curiosity that customers brought their friends to see, to an international event broadcast through radio and television. At the height of the excitement, even Mother Teresa's lawyer got involved.

People traveled from far and wide to see the now famous pastry. Store employees, used to filling drink orders and grinding beans, now spent large portions of their shifts doing radio interviews, doing drive-

38

Encased and shellacked, the Nun Bun was prepared to endure unforeseeable circumstances, with the exception of theft.

time shows for the east coast mornings, and then doing it all over again for the west coast. Posters, T-shirts and an indie documentary film were made, all in the name of the Nun Bun. What had started off as a disfigured cast-off was now a bona fide commodity. "Lloyd's of London wouldn't even insure it," Bernstein says.

And with good reason, as word traveled about the Nun Bun, Mother Teresa's lawyer wrote to Bernstein,

concerned that a profit was being turned on the like-ness. The matter was settled amicably, as no one got rich off the Nun Bun, and it was relayed to Bernstein that Mother Teresa appreciatively laughed when she saw a photograph of the pastry.

In light of this minor legal brou-ha-ha, all the media attention redoubled; Bernstein, the official owner of the sugary miracle, did take measures to preserve the cinnamon bun, namely shellac. The Nun Bun was something that would last through time. And perhaps somewhere it still does, but not at Bongo Java.

On Christmas morning in 2005, nearly ten years after Ryan Finney's derailed breakfast, someone broke into the café and stole the Nun Bun. It was the only item missing after the break-in. The police investigated the scene and filled out a report. Stolen objects are typically designated property categories, and in this case the Nun Bun was labeled a Number 77, for "other."

It's hard to say why someone would steal the Nun Bun. It's possible that it offended the wrong person, and the aggrieved individual sought to destroy the idolatrous sweet. Or, it could have been a crime similar to those of famous pieces of art, where the desired object churns through the seedy network of black markets. Either way, for Bernstein, "it was like someone stole my favorite picture of my grand-mother."

The disappearance of the Nun Bun served as an indicator as the extent to which it had made an impression on American popular culture. On eBay,

Nun Bun knockoffs were hawked. One artist, either a very savvy one or very trite one, paid homage to the Nun Bun by giving it an Andy Warhol repetitive color treatment, a la Marilyn Monroe or a Campbell's soup can.

In May 2006, the Nun Bun mystery resurfaced in *The Tennessean* newspaper. An envelope with a Philadelphia postmark and Atlanta return address arrived at the paper's offices; inside, a photograph of what appears to be the Nun Bun, resting on a beat-up statue of a nun. The envelope was sent by someone using the pseudonym "Hu Dunet" with the message "Guess where?" With an obfuscating glare running through the portion of the photograph where the cinnamon roll in question sits, it is impossible to discern whether or not this is the real Nun Bun or a hoax. Then again, it probably doesn't even matter. The Nun Bun has carved its way into the cultural fabric of America, both as an object and a myth.

To this day, Ryan Finney's friends introduce him as the "guy who discovered the Nun Bun," though he didn't take part in the media circus that ensued after that noteworthy breakfast. Finney is back at Bongo Java, however. As our interview wrapped up, Finney made one thing clear. His core conviction is that shapes that resemble faces of people we know and love are everywhere. "My mom still thinks it means something," he tells me, "but it's just like staring up into the clouds."

What is amazing, though, is that for all of the faces Finney could have associated with his would-be breakfast, Mother Teresa was the one that popped to mind.

Want to hear something funny?" Finney asks. "Not
too long ago I was playing music with friends. It was
hot, and after a while we stopped and I had a bottle
of Kool Aid, or something. Later, the bottle's been
sitting around empty for a while and I look down at
the bottom of it, the way the residual juice dried,
it looked like Jesus Christ." He laughs. "I left that
bottle right there, didn't tell anyone about it except
for my mom."

Pope Pancake

39

Aren't your eyes supposed to be closed when you pray? Perhaps he's just resting.

It wasn't a typical story for the nightly newscast on Michigan's WOOD TV. One of Myrna Kincaid's neighbors had called in about it, and then the Kincaids sent pictures of the benevolent breakfast food to the television station. According to Brad Edwards, the reporter that eventually went out to the Kincaid house to do the piece, the phrase "Pope in a pancake" became a newsroom mantra. By the time the story was assigned to Edwards, the Kincaids had already been sitting on the pancake emblazoned with Pope John Paul II's profile for a couple of weeks. Edwards, a crime and courts reporter, made the trip to Jackson, Michigan, skeptical about the legitimacy of this beneficent breakfast. "There's not a whole lot of black and white in the world," he tells me over the phone, "just lots of grey."

When Edwards arrived at the Kincaid home, however, he could not deny that the shape possessed a papal look. The pancake had been preserved in the freezer since it was first fried up. The cross stands out first and foremost, but the shape of a cross alone certainly does not qualify a shape to be that of the Pope. It is something in the bowed head, the way the forehead presses against the cross, the rounded, bowed look of the shoulders, the donning of a skull cap.

To the Kincaids, this was not just any Pope, it was Pope John Paul II. This may seem like an arbitrary designation, as all popes at one time or another have struck similar reverent poses, but the pastoral staff is a noteworthy indicator. For many years, popes carried a crozier, but modern day popes use the pastoral staff, which has a curved crucifix on the top.

Plus, the pancake was made for a Sunday morning breakfast.

Edwards couldn't deny that the image "popped." More so, as he spent some time with the Kincaids, he came to believe them as sincere people, not hucksters out to make a quick buck on eBay. He tells me, "Revelation, fluke, whatever you want to call it, it held meaning for them." Further evidence for Edwards that this mix of butter and batter occurred on its own volition, was the fact that the Kincaids ended up naming their child John, a docile child that never cried, even with a news crew in the house. "No one would name a kid after a hoax," Edwards states.

The Kincaids have since moved and were impossible to track down at the time of writing. There's nothing in the public record indicating that they sold the pancake. It's probably in the freezer. The pancake made an impression, however. When the piece ran on WOOD TV, curious folks from all over inundated the station's website with hits overnight numbering close to 70,000. For Edwards, that's the real story: impact.

Did you know?

While early popes used a crozier, starting in the eleventh century they typically carried pastoral staffs, with crucifixes on top. Both the crozier and staff are meant to resemble a shepherd's stave in that both are used to steer flocks in the right direction.

Holy Sheet

40

Another example that makes you squint, it was still worth $1,500 to GoldenPalace.com.

It took just a little more than three years of working at Hardy's Hardware store in Manchester, Connecticut, before Thomas Haley gained national notoriety. In February of 2006, while rounding a corner at work one day, Haley saw a face on a piece of sheet metal, which was on a shelf in the store. Something about the smear of an oil stain and how the light hit it revealed the face. More than just a face, Haley also saw hands on either side of the head. He showed his discovery to coworkers, all of whom agreed that there was a face on the sheet metal.

Though he does not consider himself a religious person, Haley thought it looked like Jesus. "I never said it was Jesus," Haley is quick to point out. "I said it looked like Jesus." Others saw Jim Morrison, and even Lou Ferrigno, a.k.a the Incredible Hulk. Haley bought the sheet metal for $15, the price after his 20% employee discount. The entrepreneurial Haley also put some calls into local media outlets, and soon enough the whole country was paying attention, as interested parties from all over called or visited to see the sheet metal. "People saw what they wanted to, which was great," Haley gleefully says. "One woman claimed it was Jesus, and that He cured her headache."

In light of how his discovery sparked so much at-tention, Haley, and four others, chipped in to post the item on eBay. To no one's surprise, the on-line auction drew even more attention to the sheet metal, ultimately resulting in a winning bid of $1,500. The five friends have yet to spend the money. While Haley refuses to refer to the event as spiritual, he does believe a portion of the money should go to a good

Fish From Allah

Astronotus ocellatus or Oscar Fish is a popular breed for home aquariums. The hardy fish can endure neglect, yet still provide owners the joy of noticeable growth. With a life span of 15 to 20 years, the little guppy you buy in the store will usually grow to a length of over 12 inches, weighing approximately 3 pounds. It's no surprise that Tony Walker kept tanks of the fish in stock at his store, Walker Aquatics in London.

What is surprising is that Nazim Raja found an Oscar that had the Arabic script for "Allah" emblazoned across its side. Walker describes the scene as if he's calling a horse race: "The bloke never been in a fish shop in his life. He was with a friend who needed supplies. He was looking at the fish in a tank on the floor, where no one looks. He just about had a heart attack. He tells me what it says on the fish."

The set of circumstances leading to the discovery involves friends helping friends. Raja was just along for the ride because of his friends Guy Williams and Tariq Mushtaq, who needed aquarium supplies. So a friend gave other friends a ride. This camaraderie and respect runs through the entire story, making it that much more meaningful for all parties involved, including Kazim Khan.

Raja immediately told Tony Walker about the Oscar, ensuring him that people would be very interested in the fish with the name of God written on it. He also told Walker that he wanted to buy the fish. Raja called his brother Kazim Khan and asked him to go see the fish and verify that the markings were read-able and not a figment of imagination. The next day

Khan arrived at the store and saw the same word as his brother, "It mimics the Arabic writing for Allah."

Though an Oscar fish can live for a long while, it needs to be in the right kind of water, and to create that condition in a new tank takes some time and chemistry. Khan and his brother purchased the fish for 10£, and spent about 1,000£ more for a large tank and accessories. With everything in their possession, there was still the matter of preparing the tank for the fish, now named Salam (Arabic for peace). Walker agreed to keep the fish in the store until the tank was ready. Little could he or Salam's new owners have known the excitement news of this fish would cause.

Word got out and people began to queue up every morning to see Salam before the store opened. People showed their affection and admiration for the fish by kissing the tank. A local imam confirmed that Allah's name was to be found in the scales. More so, the imam also identified on the fish's other side the word "Muhammad" (PBUH). Khan is quick to point out that these sorts of patterns on fish tend to be symmetrical, but this development made Salam's existence that much more noteworthy. Amazingly enough, with the script for "ya Allah" on the fish's right side, and the script for "Muhammad" (PBUH) on the left side, the markings replicate how Arabic is written and read from right to left.

Tony Walker's shop became hectic as the curious and devout mingled with the media. Several people tried to buy the fish out from under the rightful owners (up to this point still completely anonymous), from sums of 1,000£ to "name your price." Walker didn't

Did you know?

Written Arabic became necessary only after the Angel Gabriel revealed the Holy Qur'an to Muhammad (PBUH). The fact that the script was created for the purpose of transmitting God's divine message resulted in the aesthetic of the calligraphic characters.

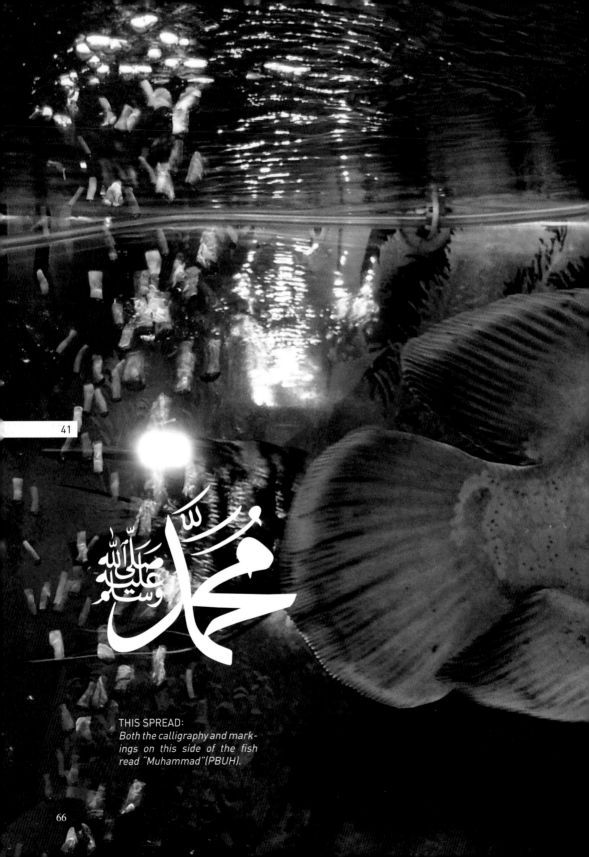

41

مُحَمَّدٌ صَلَّى اللهُ عَلَيْهِ وَسَلَّمَ

THIS SPREAD:
*Both the calligraphy and mark-
ings on this side of the fish
read "Muhammad" (PBUH).*

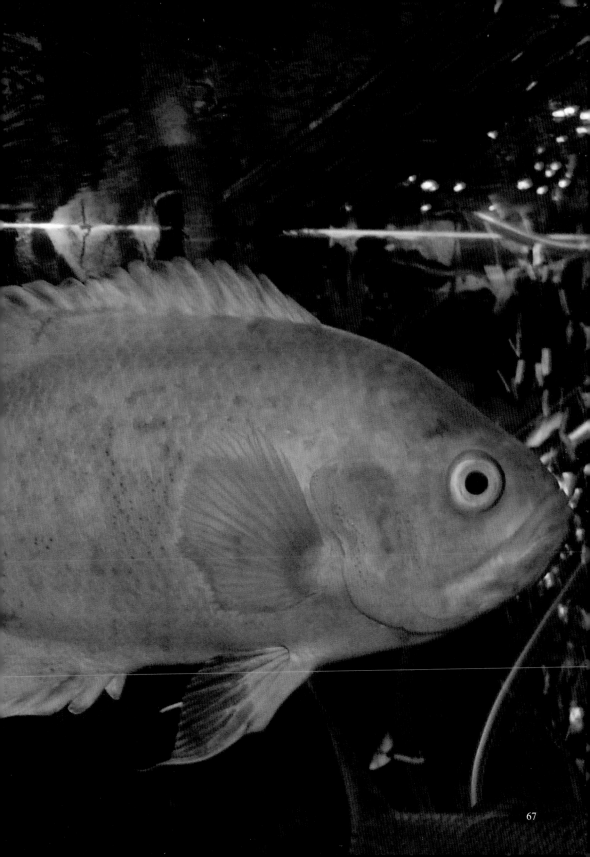

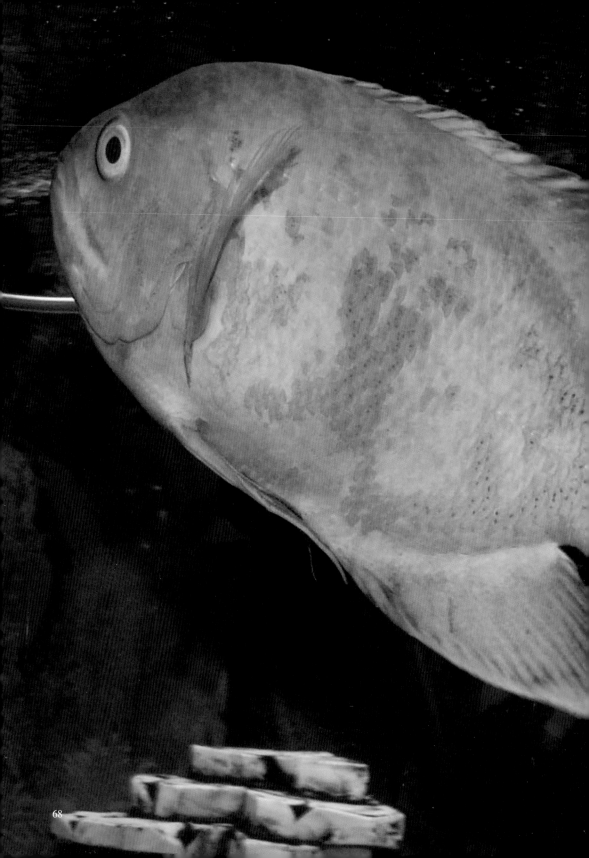

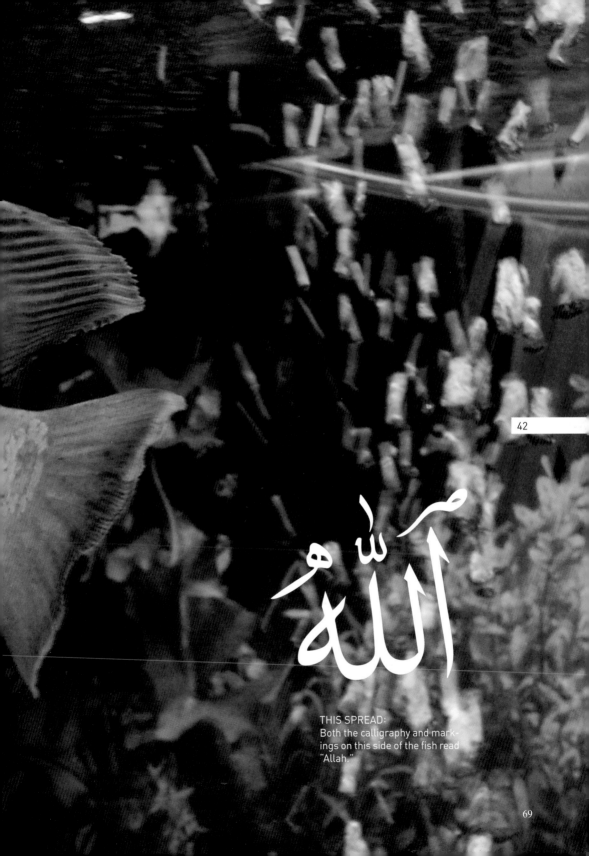

اللّٰه

THIS SPREAD:
Both the calligraphy and mark-
ings on this side of the fish read
"Allah."

entertain any of the offers. "I'm a man of my word," Walker casually tells me, "I had sold the fish. It wasn't mine to sell anymore."

Salam was discovered on January 17, 2006, remaining at Walker Aquatics until February, at which time the new tank was ready. Since then, Salam has been a fixture at Kazim Khan's home, where he and his family permit anyone that shows up to see the fish. At first, the home received anywhere from 50 to 100 visitors per day, though the pace has slowed somewhat and tends to be heaviest on weekends. Between February and September 2006, it is estimated that the home received 5,000 visitors.

Salam spends his days and nights in a large tank with seven other fish. When eager people finally find themselves before the tank, they instinctively ask, "Which one is Salam?" "I won't tell them," Khan says, "because then they are seeing what I see. This is not about what I see though. It is, if you will, about what each and every person sees." What better lesson is there than encouraging individuals to reach their own conclusions, especially in matters so personal? Khan admits that readers of Arabic can always pick Salam out since the markings are clear. "It's not just in my head," he happily reports.

For those not able to see Salam live and in living color, Khan has a website, www.fishfromallah.com, which has recorded tens of thousands of hits, and has also served as a means for people to make offers on Salam. One such email offered 30,000£ for the fish. In Khan's words, however, "I can't get past the moral side of selling him for money. Buying Salam never had a monetary purpose." And so,

Salam remains a member of the family. When people insist that they compensate Khan's household for allowing them to see this wonder, or when emails arrive wanting to donate money, Khan puts it into a fund that will go towards digging water wells in areas where potable water is scarce.

Through all of this, for Khan the most important aspect has been "assessing the impact on our lives." Like so many people who have found themselves the guardians of these phenomena, Salam has changed Khan's life, as well as his family's. His story has been transmitted all over the world by the likes of the BBC and Reuters; he has met people who he would have otherwise never met. He and his family have been offered huge sums of money, but through it all they have maintained their original intention: "We stuck to what we think is right."

Some of the people featured in this book have been accused of exploiting or profiting off these visual manifestations, and that of course is a matter of opinion. What is so remarkable about this story is that ultimately Kazim Khan sees Salam as some-thing for each and every individual to appreciate in his or her own way. When people inevitably ask if Salam is a miracle, Khan is quick to reply, "All life itself is a miracle and this fish is of one of those miracles of Allah."

Hand of God?

Russell, Arkansas, is a town with dirt roads, which lead to more dirt roads. Beneath a stand of lush trees punching out of the scrub land, Brenda Jackson woke one morning and before even getting out of bed noticed the face of Jesus on the inside of her hand lotion bottle. Situated by her Bible, clock, remote control and Mickey Mouse doll, the agape mouth looks like it is groaning in agony, or inspirationally orating. No, He's gasping for air in there.

Writer Tim Bousquet and photographer Philip Holsinger eagerly went to visit Brenda and her husband Lloyd though, because she had come to the newsroom touting photographs of her Elizabeth Arden lotion bottle. At first, her request was batted around the office as a joke, but Bousquet kept on his editor about going out to the Jackson home. About two weeks after she had first discovered the face, Bousquet's editor finally sent him.

Bousquet refers to the region as "stereotypically Arkansasian." As a reporter for Searcy, AR's, *The Daily Citizen*, the only other story Bousquet had traveled out to Russell for involved the suspicious death of a person whose father, grandfather and great grandfather were all the same man. (Diagram it, it is a shockingly plausible scenario.)

Brenda Jackson greeted the two men with an eager smile, bright like the ornaments and birdfeeders dangling from the tree branches underneath which sat the Jacksons "trailer-like home." Jackson had wanted the world, or at least Arkansas, to know about her discovery. A self-proclaimed believer, she

confessed that her job at Walmart included Sunday shifts so she didn't regularly attend church. The reason for this manifestation baffled her.

The bottle is nearly empty, and the residual lotion clings to the inside of the bottle to form a pattern that looks like Jesus. That we see the primary visual icon of a religion due to any number of circumstances like temperature, light and chemistry is astounding. The right physicist or chemist could scheme up some reason for the why lotion acted in such a way as to form a face; doubtless, the explanation would include words and phrases like "viscosity," "temperature sensitive" and "algorithms," but it would be no different than saying that it is simply a miracle in a bottle. It really doesn't matter. Most people can see it; some of them believe in it as a sign, others don't.

Brenda woke her husband up to see, and before she said anything he saw the face the same as her. That's when she knew it was time to make the trip into Searcy and tell the newspaper.

The two journalists went to see the Jacksons, knowing that a woman had found Jesus in a bottle. In Bousquet's words: "In that part of the country, religion sometimes comes with a big chunk of war fever. But she was just a really good person. She believed and wanted to share what she could."

Reality check: The newspaper that ran this story, Searcy, Arkansas's, The Daily Citizen, does not keep archives that date back to when the piece ran: Friday, April 16, 2004. The image quality is poor, but it is a valuable reminder that even in the United States, not everything functions at 21st century speed, even daily (with the exception of Mondays) newspapers.

43

Choco Mary

From time to time at Bodega Chocolates, stainless steel tables catch chocolate that drips from the vats. Typically, the chocolate dries in thin, flat discs. On a Monday morning in August 2006, underneath a vat of dark chocolate, however, Cruz Jacinto found an unmistakable shape: a 2-inch-tall Virgin Mary. She noticed the figure immediately, instantly thinking of the prayer card she carries in her pocket that has an illustration of the Virgin Mary.

The way the melted chocolate fell and cooled certainly created a human form. The markings on the front of the figure look like folds in a dress, which bells out at the base. The head, cradled into the shoulder, possesses an unquestionably feminine quality. And then there is the small white dot nested into the torso, to Jacinto, the Baby Jesus.

Since its inception, Bodega Chocolates, located in Fountain Valley, California, has been a popular choc-olatier with the Hollywood set, but this discovery has done more for the company than any awards show photo-op, says Martucci Angiano, the company's co-owner: "We've been blessed with success, but this has done more for company morale than anything else."

I ask if there has been a spike in business. Angiano laughs and admits, "I think I've given away more chocolate than anything." When first discovered, the figure resided in the gift shop, where visitors could easily see it. It now resides in Angiano's office, where the curious are still welcome to pop in and take a look. In the wake of the media attention generated

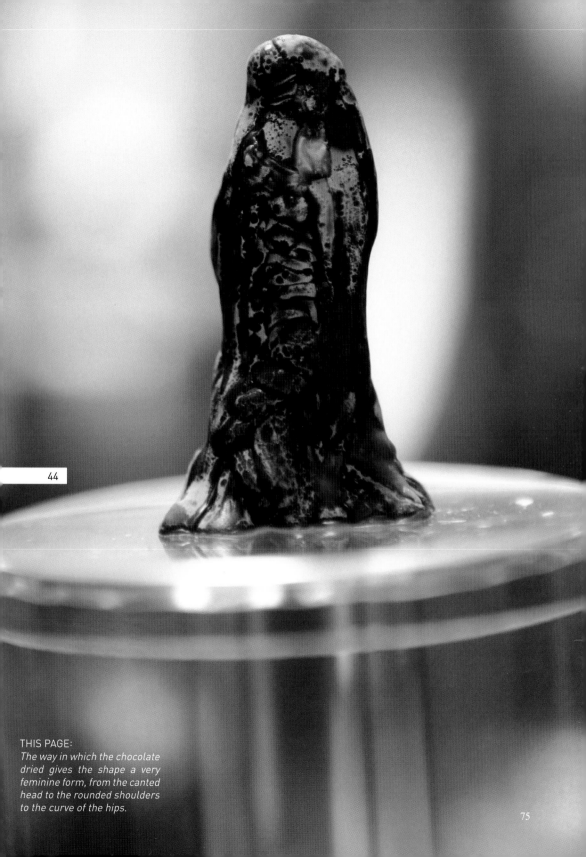

44

THIS PAGE:
The way in which the chocolate dried gives the shape a very feminine form, from the canted head to the rounded shoulders to the curve of the hips.

by the manifestation, the visitors did pour in, not only from California, but also from as far away as Quebec, Ontario, and even though time has passed since the Chocolate Virgin was discovered, people still show up to look at Her.

Potential buyers have also surfaced. One person even went so far as to offer $30,000 for the figure. "I wouldn't sell it for $60,000," Angiano proudly states. When speaking with Angiano, it is clear that this event cannot be appraised in monetary terms. When news of the discovery broke, it was well publicized that Cruz Jacinto had been having a dilemma of faith, but now her perspective on life has completely changed, and the change doesn't end with her. "Everyone here feels that Bodega is protected," Angiano says.

As the phone conversation winds down, Angiano tells me that she can see some people have shown up, people, she is certain, who have come to look at the Chocolate Virgin Mary. "You can always tell the ones who are here on personal business." It is clear that Angiano, Cruz Jacinto and the entire Bodega Choco-late family consider this visitation a very personal affair. It has brought the company closer together and given them something other than chocolate to share in common.

Martucci Angiano, co-owner of Bodega Chocolates, in her office with the Chocolate Virgin Mary. The figure has made the entire company feel blessed.

45

Grilled Faith

If Myrtle Young is the first celebrity created by in-animate objects that look like people and animals, Diana Duyser is the 21st-century second-coming paredolia celebrity, all because of a grilled-cheese sandwich. There are many remarkable aspects of Duyser's Virgin Mary burned onto this divine lunch. For one thing, Duyser and her husband Greg kept the manifestation private for years, though Her face was noticed immediately as Duyser took a bite out of the sandwich — a foodstuff transfiguration created from the alchemy of Land 'o Lakes Cheese, Publix brand bread and no oil or butter.

Neither Diana nor Greg will ever forget the day the sandwich surfaced. And how can they? Today, they often travel with the sandwich, midwives to what many see as a miracle, beckoned to accompany it wherever it may be on display.

Such was the case when I sat down with the two of them, and the encased sandwich, in the Times Square hotel where they stayed as a result of being in New York for an ice cream eating contest. Sitting in the lobby, they looked like any other tourist couple taking a load off from the hectic city pace, with one exception. On the coffee table in front of them, a durable suitcase was open (think something out of a James Bond flick) and propped up in the case, a box with a clear plastic front inside of which was another plastic case. This smaller case is the same one the Duysers initially installed the sandwich in when they first discovered it, and let it reside on their mantle, for years a private memento. Held in place by noth-ing more than cotton swabs, the triangular sandwich

Did you know?

During the summer of 2006, the online gambling casino Goldenpalace.com launched their traveling Museum of Oddities. On display in the trailer that cruised all over the United States, items like the Grilled Cheese Madonna, Jesus Pieorgi and William Shatner's kidney stone. The grand total spent on the museum's collec-tion: $293,671.76.

half has never been treated or altered in any way, though there is no mold or sign of deterioration (with the exception of a broken corner attributed to airport Homeland Security Inspectors).

And sure enough, emblazoned on the bread in heat-browned lines, with eyes uplifted, a porcelain nose and a tightly pursed ovaltine set of lips — a woman's face to be sure.

Diana Duyser with the Madonna Grilled Cheese in New York City.

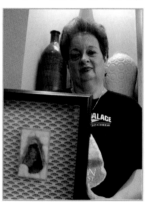

46

Diana had taken her first bite of lunch, but then she thought to look at the sandwich in her hand, notic-ing the face staring right back at her. She shouted for Greg to come look. "It kind of scared me at first," he recalls. Both the Duysers were overwhelmed by the appearance of the face, but soon the manifesta-tion delivered upon them a sense of tranquility and ease. At the time, the Duysers were busy tending to the vagaries of aging parents, so the toast remained a private reassurance during an otherwise busy and emotionally taxing period. And it brought Diana an amazing amount of luck. Over $50,000 of luck, to be precise, collected over the course of seven or eight big wins on video super six lotto in a casino by her home.

I asked her if she thought it was a miracle. The action of the hotel lobby seemed to burn away from her attention as she longingly stared at the toast, as if awaiting an answer. "Yes, I guess that's all you can call it, a miracle."

The Duysers are not practicing Christians, though Diana has often stated that she does believe the face to be that of Mary, Mother of Jesus. They do not regularly attend church and when talking to them

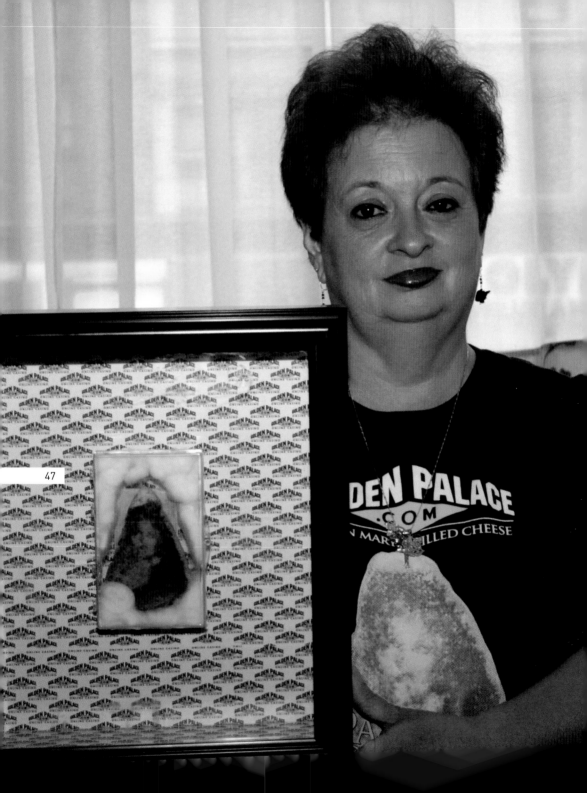

about the grilled cheese sandwich, they sanctify it in personal terms, especially Diana. During the ten years when only the family and a few close friends knew about the toast, Duyser reaped peace of mind from the beatific face. It communicated with her, and continues to every time the two reunite. "She brings me peace."

It was this quality that the Duysers wanted to share with the world when they decided to auction the Virgin Mary Grilled Cheese on eBay. Little could they have known how this one half of a sandwich, which had already changed their lives, would take on such magnitude of meaning for hundreds of thousands of people all over the United States, and change the very nature of eBay.

The eBay story has been well documented in the press. The Duysers posted it at the online auction house, a flurry of bidding ensued; eBay pulled the item down thinking it was a hoax. After much insistence that the sandwich was indeed real and would go to the highest bidder, the item was reinstated and the online casino GoldenPalace.com purchased the sandwich for $28,000!

In a way, this is where the story really begins. Even now, no longer the official owners of the object, a day doesn't go by for the Duysers without mention of the sandwich. "I just travel with the cheese," Duyser happily concedes. But this is an over-simplification of her and her husband's role in the sandwich's public life. As the conduit through which the face formed, Diana inspires as much reverence and awe from admirers as does the piece of burnt bread. At home in Florida, fans regularly stop Diana with questions

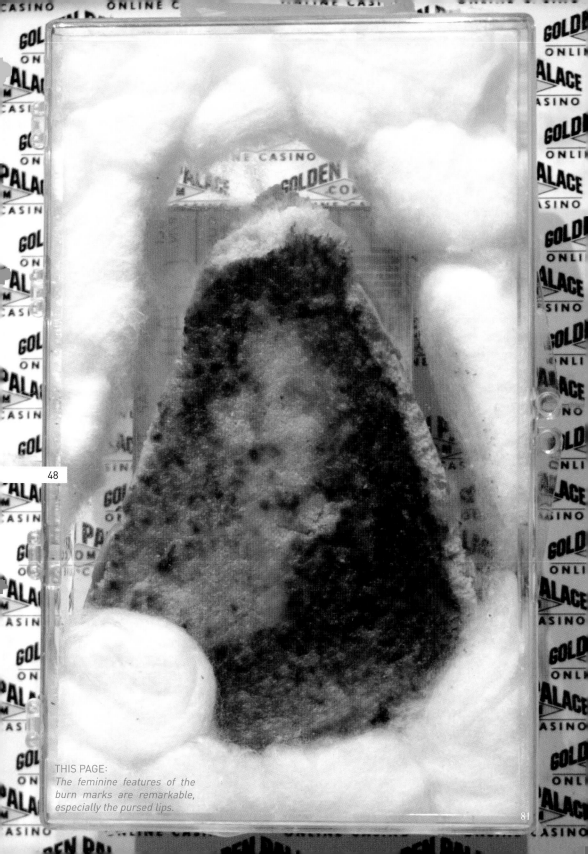

THIS PAGE:
The feminine features of the
burn marks are remarkable,
especially the pursed lips.

and requests. Just the week before we met, she had been shopping at Publix, the same market where the ingredients for the sandwich were purchased, when a woman in a wheelchair asked Duyser to pray with her and touch her legs. Duyser obliged, as she always does, because it gives these strangers hope and feeds their faith, no matter the shape of that faith. "Everyone has their own belief about what She means," Diana says, the genuineness unmistakable in her soft-spoken voice. (Greg Duyser was quick to add on the heels of the Publix story, that he's friends with the store's manager — he has confided in Duyser that since the eBay attention, sales on Land 'O Lakes cheese and the bread have skyrocketed.)

If the reference to Myrtle Young's potato chip collection on the *Simpsons* is how that phenomenon will live on forever, Diana Duyser will never have to worry about her sandwich being forgotten, since it has been disseminated through every conceivable popular culture route. Though there are many people who interpret the face as a bona fide religious miracle, the sandwich staggers even more people because of the story, and its near perfect human face.

So, when the sandwich traveled to the MTV Music Awards, the box garnered a great deal of attention, and even scored three autographs, which remain on the box's white backing: Lindsay Lohan ("She about had kittens."), The Rock, Quentin Tarrentino. The Duysers have had celebrity run-ins with the likes of Daryl Hall and John Oates, Penn and Teller and Steven Seagal; they've been featured on all the television networks, in magazine's as varied as *People* and *Wired*, and there is a feature film in the works. Perhaps the ultimate nod, however, to Diana

Duyser's permanent spot in the popular culture pantheon is her appearance on the reality television show *Miami Ink*. Though the Duysers are often called to make an appearance with the grilled cheese sandwich, it is something they no longer own. Diana misses the sandwich; at this point it's a like a member of the family. To that end, Duyser agreed to go on *Miami Ink* to get a tattoo of the sandwich, so it would always be close to her heart.

It's a story that involves all of the trappings of the 21st century: the Internet, large amounts of money, celebrities, religion. Ultimately, though, this is a story of a very personal connection between Diana Duyser and a grilled cheese sandwich she just happened to make one day for lunch . . .

The most important lesson of it all for Diana Duyser? "Now, I always check what I eat."

49

Autographs collected at the MTV Video Music Awards: Lindsay Lohan, director Quentin Tarrentino, The Rock.

Epilogue

Epilogue

More than a Flash in the Pan!

So where does this leave us? Here at the end of this collection of popular culture artifacts and the stories behind them, to me, it all fits together tongue-and-groove. Secular or religious, these visual manifestations are borne from the same places: our minds. This is not to say that they lack any degree of poignancy or divinity, but whatever the source of these events — a spiritual surfacing in this temporal world of ours or simply a matter of physics and chemistry – they filter through our brains. Tucked into those cerebral folds, countless associations and memories await a synaptic firing that brings them back to life.

50

It doesn't matter if you grew up with a religion or an always-turned-on television, the iconography of both cultures has a roaming ability to affect all of us as they coexist and commingle, and that's what this book samples. There are countless more examples of these phenomena out there in the world, and plenty more are destined to crackle through a fried egg or splatter in a plop of bird droppings. But it doesn't end in the ceaseless cycles of these happenings.

51

Because she no longer owns the Virgin Mary Grilled Cheese, Diana Duyser got a tattoo of it so it will always be close to her heart.

What really matters is the lasting impact of these icons (and in the case of Diana Duyser's Grilled Cheese Madonna tattoo, it is an indelible impact). Though many of these stories end after the initial media frenzy, many of them do not end. They become part of the cultural fabric, and in turn help inform how we understand ourselves and the world we all share.

Just look at Myrtle Young. To this day, she gets requests with regard to her potato chips. She has her place in the celebrity family tree, a distant cousin of Johnny Carson and Homer Simpson. Young did not seek this status, the media delivered it to her with its ability to rehash, revisit and recreate the same story until it is made a permanent part of the culture. And so it follows that other such visual manifestations have been, and will continue to be, catapulted to similar levels of recognition — or at least try.

At the peak of the Nun Bun's notoriety, the sweet morning treat attracted media coverage that even reached Mother Teresa. The high profile bun caught so many people's attention that it was robbed one Christmas morning. But the story doesn't end there. In the spring of 2006, a reporter at *The Tennessean* in Nashville, Tennessee, received a ransom note, replete with a photograph of the captive Nun Bun. As absurd as it is relevant, this act proves the extent to which this object has made an impact on the person, or people, that currently possess the Nun Bun. For those who cherish the memory of Mother Teresa (and I mean really, really, really cherish) it isn't too farfetched to understand why such an individual would consider the cinnamon bun idolatrous and want it removed from the public gaze. But evidenced by the ransom note is the desire for the story to be continued in the media spotlight. I'd bet that wherever the Nun Bun currently resides, it is a running joke that the bun-nappers laugh about frequently. They possess an object that can ensure them instant media attention whenever they want it.

Diana Duyser's Grilled Cheese Madonna tattoo takes the topic to a whole other level, and is as appropriate a place to conclude this book as Myrtle Young's

potato chip collection was to begin it. Young's collection was borne out of the analog 1980s, when television and radio were the fastest ways to transfer information. While the shapes are unquestionably recognizable, they lack the trappings of the hi-def reality we've all become so accustomed to here in the 21st century. And so, for all of her media appearances in the past, Myrtle Young has essentially escaped the blog-o-sphere, her name still just a blip when Googled.

The Internet, however, made the Grilled Cheese Madonna famous. The eBay auction set records, and the winner of the auction, the online casino Golden Palace.com, has mastered online publicity, making a name for themselves spending huge sums of money on everything from a Lady of Guadalupe Tree to Britney Spears's half-eaten egg salad sandwich.

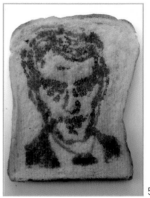

52

The reality of celebrity has become the celebrity of reality, and it is all delivered to us on screens, screens we sit in front of all day, screens we hang like art on walls, screens we hold in our palms, attach to our belts and install in our cars.

Retail iconography has gone beyond prayer candles and crucifixes. Cashing in on the iconographic aspect of pareidolia as pumped through the media, several make-your-own Jesus Grilled Cheese sandwich makers are available through retail gift chains like Urban Outfitters. The As Seen on TV Jesus Pan website declares: "Put the image of Jesus *RIGHT ON FOOD*!"

53

From LaCrosse, Wisconsin, Tim Pahs offers an artisanal handmade cast iron frying pan. From concept and design to the pouring of molten hot iron, Pahs's pan, while for sale, is an artistic statement. When a

From toast to Marmart, Dermot Flynn uses tracing paper, Marmite's squeezable container and a healthy knowledge of British popular culture. Would you take a bite out of Jude Law's face?

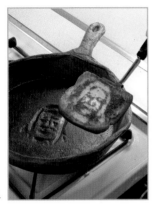

54

Using the face of Jesus from the Shroud of Turin, Tim Pahs hand-crafts cast iron pans that you can use to cook up a slightly burnt bite of satire.

Did you know?

When Marmite first hit the market in 1902, this pungent and potent British yeast-extract spread was packaged in an earthenware pot, which in French is called a *marmite*, and a brand was born. Notoriously considered an acquired taste, the vitamin-rich spread is typically used on toast and biscuits, though more adventurous epicureans use it for cooking or curing hangovers.

piece of bread turns to toast in his pan it burns the face of Jesus. Not just any face of Jesus, however, the face from the Shroud of Turin. Pahs conceived of the project as a response to the overt presence of religion in all of our lives, from politics to Hollywood. To that end, the first pan crafted by Pahs was put up on eBay on May 19, 2006, the same day *The Da Vinci Code* film opened.

Across the pond, another artist, Dermot Flynn, has also contributed a take on recognizable faces appearing on toast, thanks to the yeast extract Marmite. Promoting the launch of a squeezable container, Marmite asked people to use the new product to draw on toast and create "Marmart." Using the company logo "You either love it or hate it," as inspiration, Flynn responded to the call for entries by producing ten notable British personalities on toast, all rendered in Marmite — from a Spice Girl to Jude Law to American Idols most acerbic judge, Simon Cowell. Flynn approached the Marmart project aware of the fact that toast and other objects have hosted an array of famed faces and sold for large sums of money. For Flynn, the project was a true tongue-in-cheek affair, but it caught Marmite's attention, which resulted in the ten pieces of toast being put on display in a London art gallery.

This is the relevance of these objects as they are transmitted everywhere, cued to infiltrate our minds, regardless of what we think of their validity or meaning. And so, it means something that Diana Duyser got famous because of eBay, but it means even more that her fame continues on reality television by getting a tattoo of the object she no longer owns. The television appearance sends her back into Inter-

net orbit, where links expand as extensively as the universe that hosts our tiny planet. The cycle never ends, though it continually regurgitates.

All of the objects featured in *Madonna of the Toast* were created by the convergence of circumstances that will never be fully understood. In most cases, the media attention and consequential celebrity is imposed on the objects and their creators/discoverers. Yes, certain of these people have made their discoveries public and taken action to use the publicity for their benefit, but it is the media and the public that induct these iconic whatnots into our pop culture curio cabinet.

Realize that when you look at the images in this book, you are looking at photographs that are undeniably human in where they come from, and in turn are undeniably connected to you and me.

IMAGES COURTESY OF:

Cover: John Putnam
01-04: David Dunsmore
05: John Putnam
06-15: Tim Perroud
16-18: Phil Plait
19-20: Phil Callaghan, courtesy of George Woodhall
21: Ron Dahlquist
22-23: Tom Burton, courtesy of *Orlando Sentinel*
24: Tony Unstead, courtesy of *Fortean Times*
25-26: Courtesy of Anonymous
27-29: Mark and Candy Podolsky
30-31: Annabel Hine
32-33: Courtesy of GoldenPalace.com
34: Courtesy of GoldenPalace.com
35-36: Bryan Dora
37-38: Bob Bernstein
39: Courtesy of WOOD TV, Grand Rapids, MI
40: Thomas Haley
41-42: Kazim Khan
43: Philip Holsinger, courtesy of *The Daily Citizen*,
 Searcy, AR
44: Nick Ut, courtesy of the Associated Press
45: Martucci Angiano
46-49: John Putnam
50-51: Jon Wolf
52-53: Courtesy of Dutch Uncle Agency
54: Tim Pahs